D1092388

# Brooklyn Storefronts

# Brooklyn Storefronts

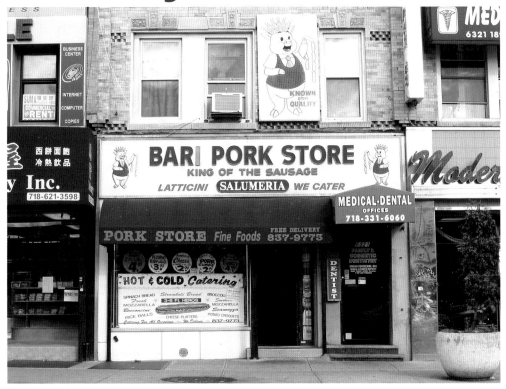

## Paul Lacy

W. W. Norton & Company | New York London

Brooklyn Storefronts
Paul Lacy

Copyright © 2008 by Paul Lacy

All rights reserved
Printed in Italy
First Edition

Book design and composition by Laura Lindgren
The text of this book is composed in Remontoire and Boton.

Title page: 6319 18th Avenue, Bensonhurst

Manufactured by Mondadori Printing, Verona

Library of Congress Cataloging-in-Publication Data
Lacy, Paul.
  Brooklyn storefronts / Paul Lacy. – 1st ed.
    p.  cm.
  ISBN 978-0-393-33002-1 (pbk.)
1. Brooklyn (New York, N.Y.)–Pictorial works.  2. Storefronts–New
York (State)–New York–Pictorial works.  3. Signs and signboards–
New York (State)–New York–Pictorial works.  4. Street
photography–New York (State)–New York.  I. Title.
  F129.B7L23 2008
  974.7'230440222–dc22                        2007035451

W. W. Norton & Company
500 Fifth Avenue, New York, NY 10110
www.wwnorton.com

W. W. Norton & Company Ltd.
Castle House, 75/76 Wells Street, London, W1T 3QT

1 2 3 4 5 6 7 8 9 0

# Foreword

Every Brooklyn neighborhood relies on its small, independently owned stores. Barbershops, botanicas, groceries, mom-and-pops of all kinds: none is exactly the same as the next. Each reflects the vision of its owner and serves the needs of its clientele. The pictures in this book look at the public faces of these stores. The focus is on the physical storefront: the collage of metal, glass, wood, plastic, and paint that is often the result of decades of construction and revision.

This book came about somewhat by chance. I'd been taking pictures of storefronts for a while already when the owner of a garage with a twelve-foot-high flag of Trinidad painted on the door asked to see some of my other pictures. The prints I put together for him I also showed to a friend, who passed them to his friend Jim Mairs, publisher of a number of excellent books of photography, art, and unusual collections. Much to my surprise, Jim saw a book in them.

I had never really thought of myself as a collector of something unusual, since these storefronts are all to be found right on the streets of Brooklyn, the most populous borough in New York City, but I concede that collecting pictures of them is a bit odd. Come to think of it, quite a few people did ask what on earth I was doing when I was out gathering the images.

It was 2001 when I first started to take photographs of storefronts in Fort Greene, the Brooklyn neighborhood where I lived. At the time the area was attracting a lot of new businesses. Rents were rising fast. One day the corner bodega closed down. In New York, a bodega is like the general store in a small village. Anything you really need can be found there–one-stop shopping. This particular bodega, before it closed, usually had a television tuned to a Spanish station, where you could see soccer and baseball, news, and telenovelas. People would gather to watch it and to meet friends and share news of family. It was a community center. It was even a bank. The family that ran it let their customers buy goods on credit. The balances were written in a ledger kept behind the counter.

This bodega was not a legendary place. No one ever wrote about it in a travel magazine. It was just an honest, dependable store, but it was also a safe haven. At night, the brightly lit store window was a sign of life when the streets were empty.

Not long after the bodega closed, a fancy restaurant opened in its place. I knew what this meant: my rent would be going up soon, too, and I would be moving.

I didn't really want to go and, maybe as a way to avoid facing the inevitable, I began to take pictures of the old places I had grown to love and to depend on for food, haircuts, shoe repair, etc.: all the places that operated on a small scale and provided essential services to the neighborhood.

Once I had gone around and taken pictures of the stores near my place, I walked to the next neighborhood and took more pictures, and then to the next. After that I got on my bicycle and rode until I was somewhere I had seen only on the map. Bedford Stuyvesant,

Crown Heights, Cypress Hills, Flatbush, Red Hook, Sunset Park: despite their renown, and the fact that I had lived in Brooklyn for nearly twenty years, I hadn't seen much of them before–and there was so much to see! Each neighborhood had its own character, its own history, its own sounds, sights and smells. It was wonderful and amazing, like traveling, but without the jet lag.

I also returned to the neighborhoods along the waterfront from Greenpoint to Gowanus, where I had lived at one time or another. There were many stores that had weathered the years. Some seemed old when I first saw them. They were like windows that looked back in time, but their persistence meant things hadn't altered beyond all recognition. There were a lot of new stores, too. So it was as it has always been, a place continually changing.

Sometimes I'd end up talking to people, asking them about their sign or their store or what was going on in their neighborhood. There's a lot of information available in books about the history of Brooklyn, but you can still learn something by talking to people. In turn, a lot of them asked me what I was doing and why. Honestly, though, I wasn't sure what I was looking for, or why I was taking pictures, only that there were many storefronts that I found to be interesting and even beautiful, and one other hard-to-define quality: that the place be cared for, that it be as needed and loved as my old corner bodega.

There are plenty of other kinds of signs besides handpainted ones, but that, mostly, is what you'll find in these pages. Granted, "you can't judge a book by its cover," but a small, independently owned store is singular and so is a handpainted sign. When you see one,

you have to wonder whether there will be something inside not found in the other stores, let alone the chains and franchises. Very often there is: a lovingly made dish made from a family recipe, a display of photographs or posters, a funny story, catchy tunes from another land: there are so many surprises.

Many of the signs are new and evidence the continued liveliness of the sign painter's art. The deftly brushed lettering of the signs, sometimes done on location, conveys an immediacy and sense of place that is absent from much of the contemporary streetscape. If you look closely at the letterforms, you'll notice that there are a few professionals whose unmistakable hand can be seen in more than one storefront sign. In this collection there are also many unique works and some homemade signs that simply charmed us.

Despite their timeless appeal, these signs don't last forever. Five years after taking the first pictures in this collection, about a fifth of the storefronts are greatly changed. Their signs have been painted over, or replaced by a new sign, or the business has changed altogether. And there are new stores with new signs. In this sense the book could never be complete.

I would like to thank Jim Mairs, editor at Norton and publisher of Quantuck Lane Press, who took a boxful of photos and discovered in them a story, and guided this project to its present form, with his assistant Austin O'Driscoll and the designer Laura Lindgren. This book would not be in your hands without them. There are many other friends to thank: Roy Tedoff, native of Brooklyn, for a key aesthetic observation; Vikii Wong, native of

Brooklyn, for her interest and criticism, and for guiding me on neighborhood walks where she taught me to appreciate the old-school flavors; and many others who inspired me and helped me along the way: Rubina Yeh, Maria Levitsky, Laetitia Kouassi, Robin Dijkstra, Chris Warnick, Christina Yang, Nura Qureshi, Ricardo Gotla, Babs Reingold, Beatriz Zengotitabengoa, Charlotte Harvey, Steve Jackson, and my brother Chuck. Thank you all. A super special shout-out to Patricia Naftali, whose delight in Brooklyn's painted treasures has encouraged me to continue and given me hope that their charm may well be universal.

Paul Lacy, September 2007

791 Rogers Avenue, Flatbush

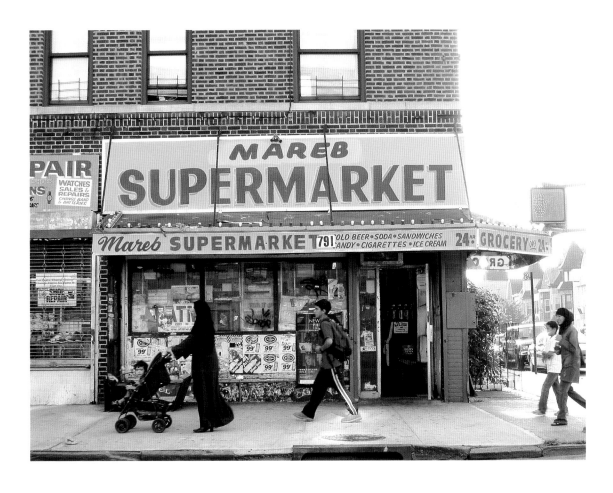

628 5th Avenue, Park Slope

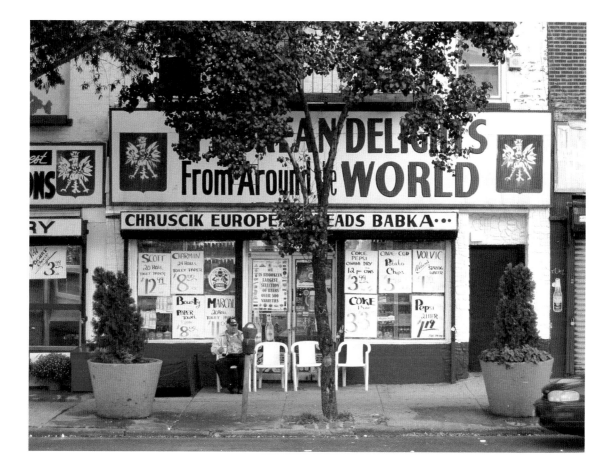

3131 Fulton Street, Cypress Hills

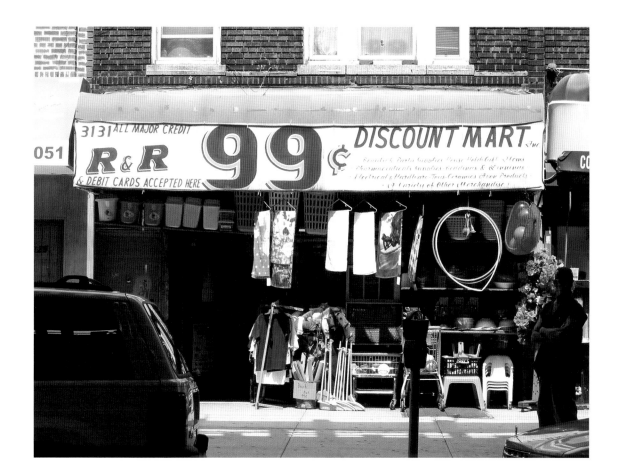

3346 Fulton Street, Cypress Hills

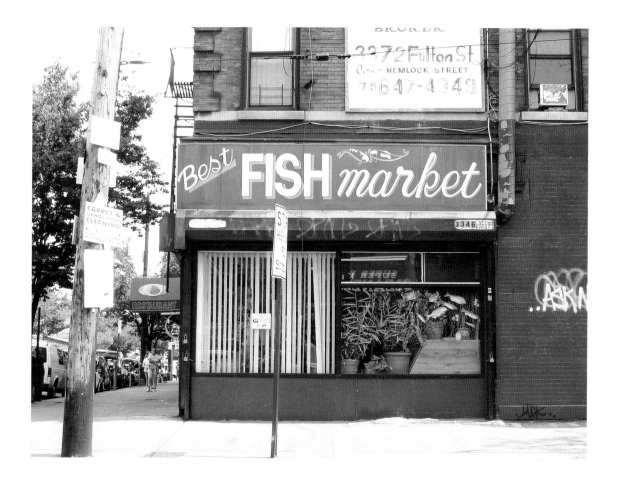

964 Jamaica Avenue, Cypress Hills

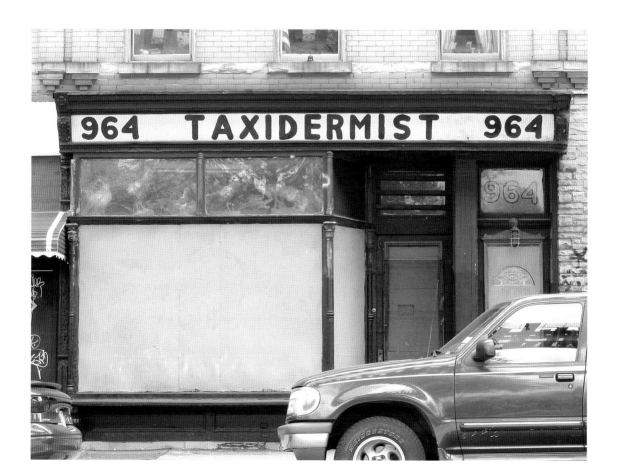

730 Flatbush Avenue, Flatbush

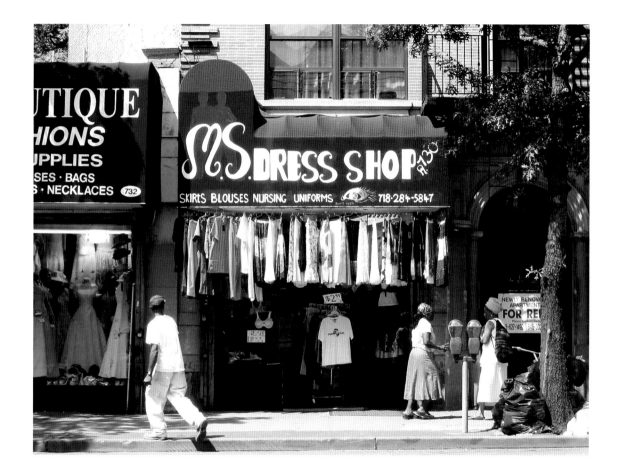

245 Wilson Avenue, Bushwick

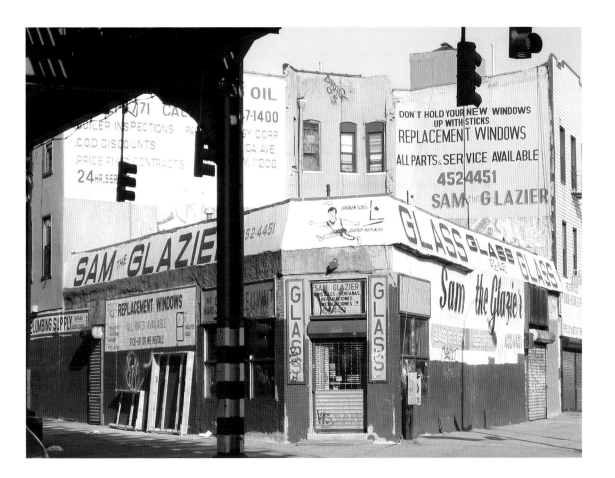

2080 Flatbush Avenue, Flatlands

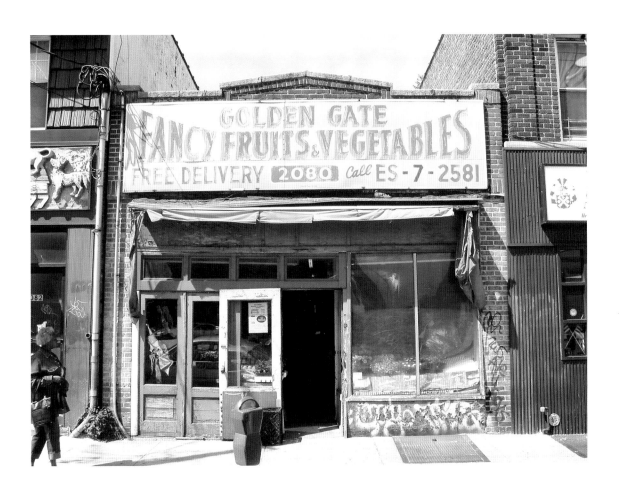

72 Utica Avenue, Crown Heights

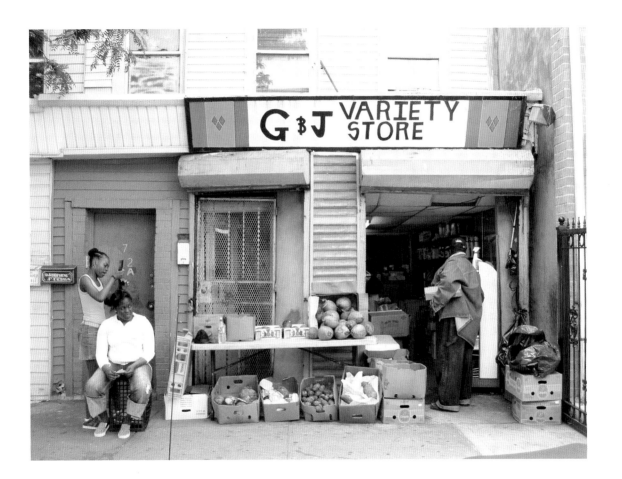

700 Washington Avenue, Prospect Heights

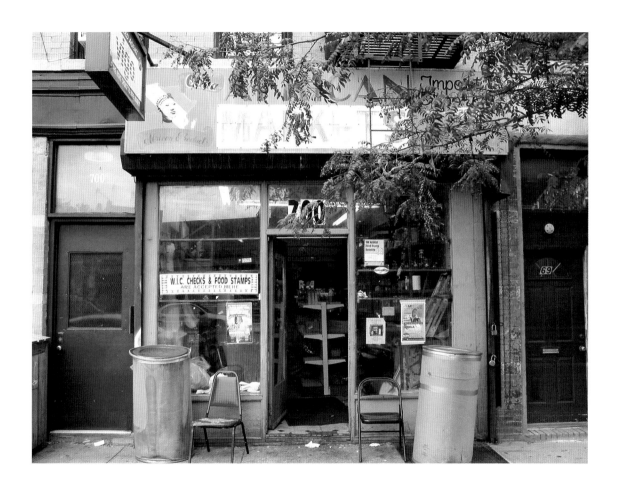

1453 Flatbush Avenue, Flatbush

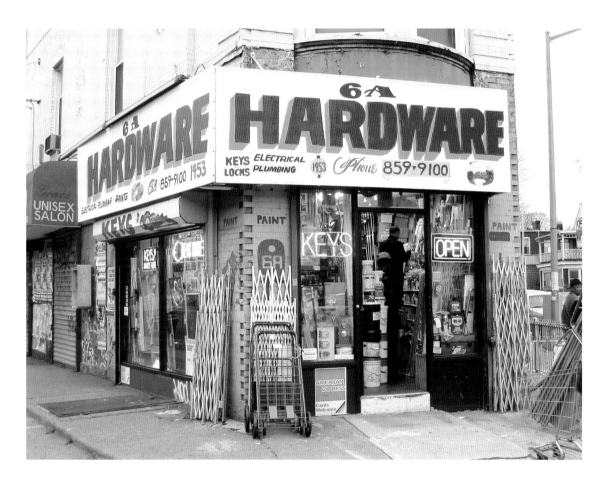

131 3rd Street, Gowanus

3035 Emmons Avenue, Sheepshead Bay

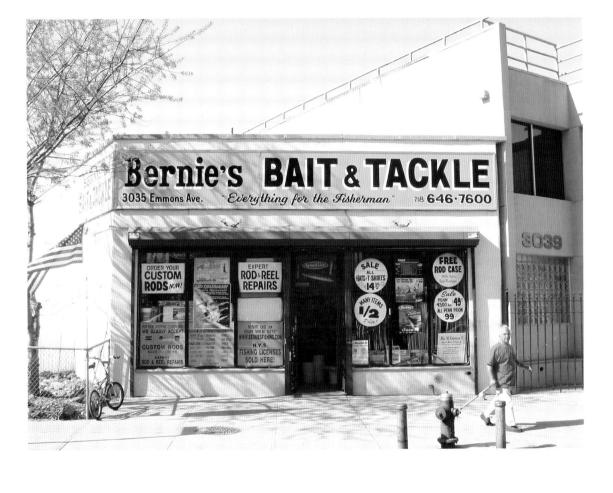

142 Rockaway Avenue, Ocean Hill

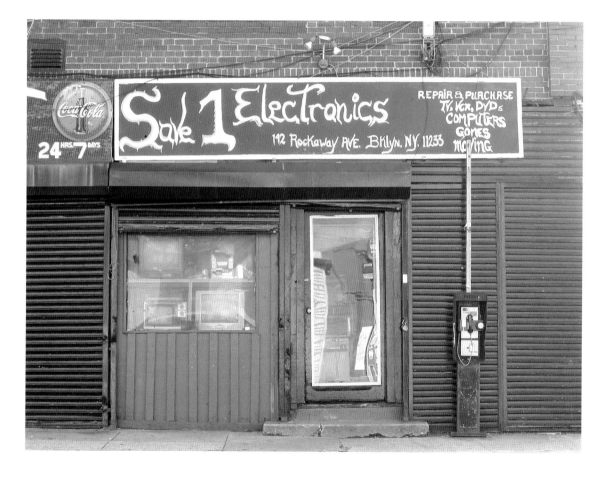

46 Wyckoff Avenue, Bushwick

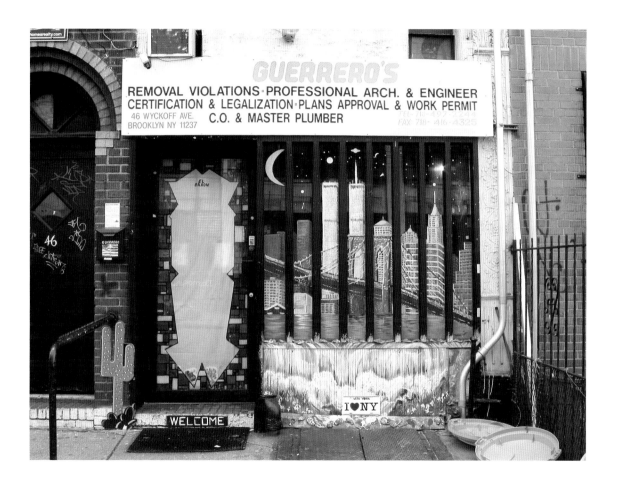

403 New Lots Avenue, New Lots

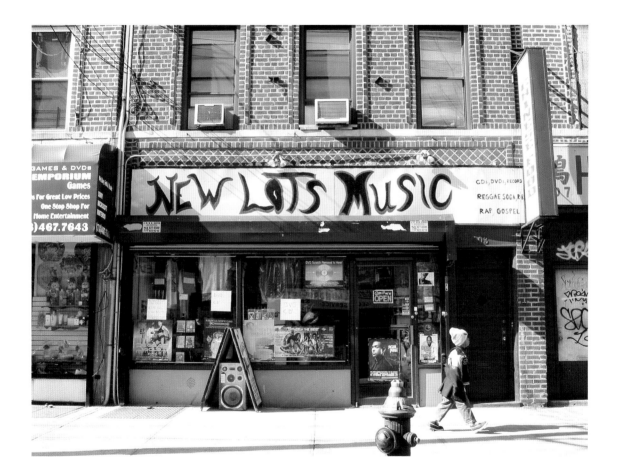

1682 Pitkin Avenue, Brownsville

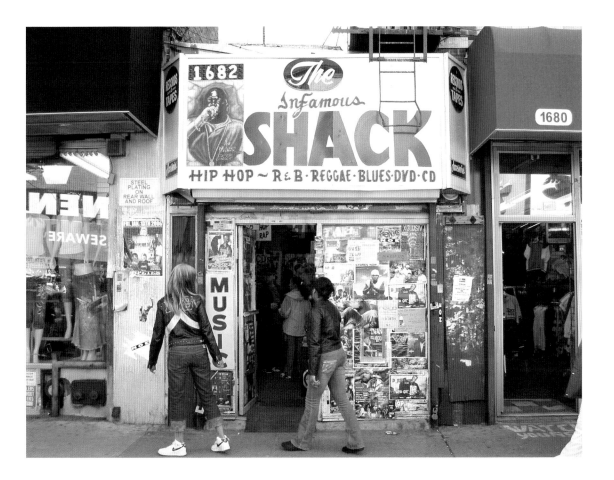

1190 Rogers Avenue, Flatbush

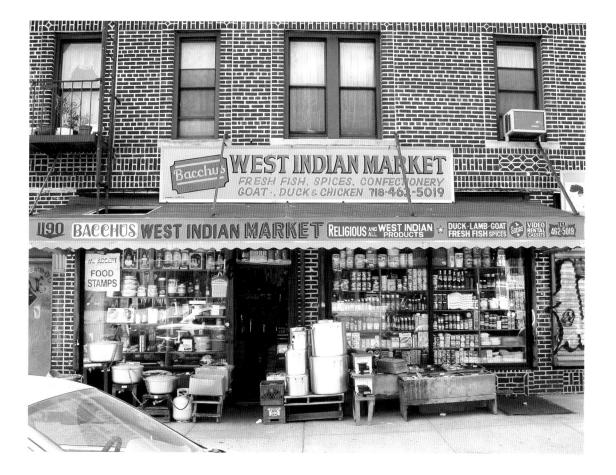

327 Keap Street, Williamsburg

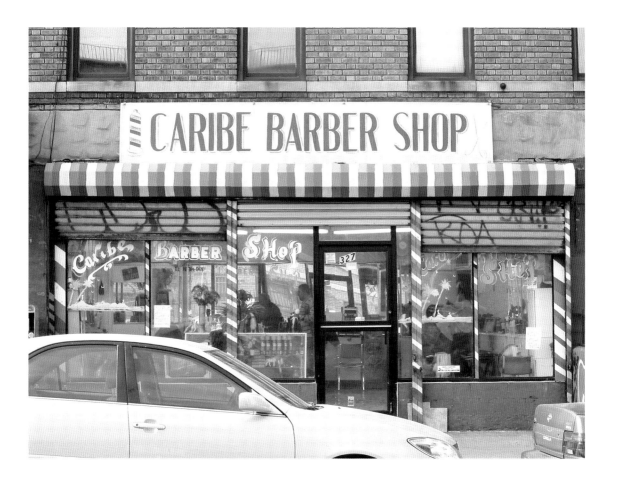

303 Himrod Street, Bushwick

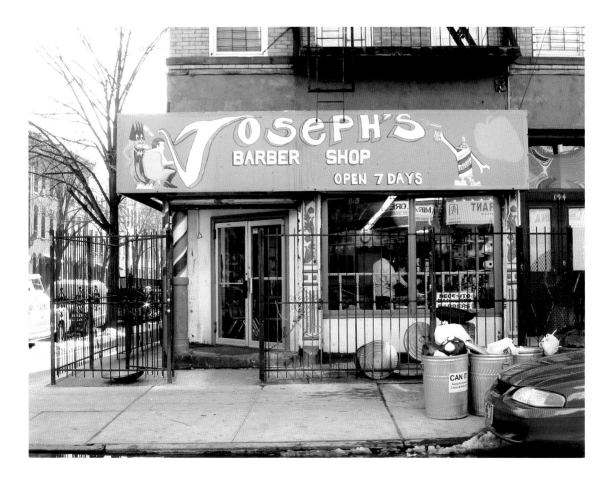

1312 Dekalb Avenue, Bushwick

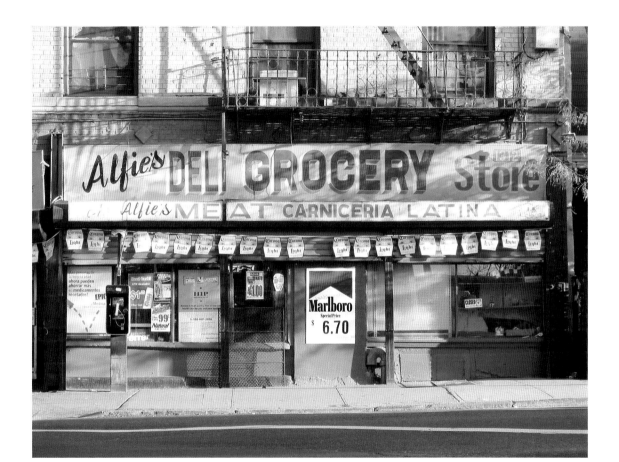

670 Flatbush Avenue, Flatbush

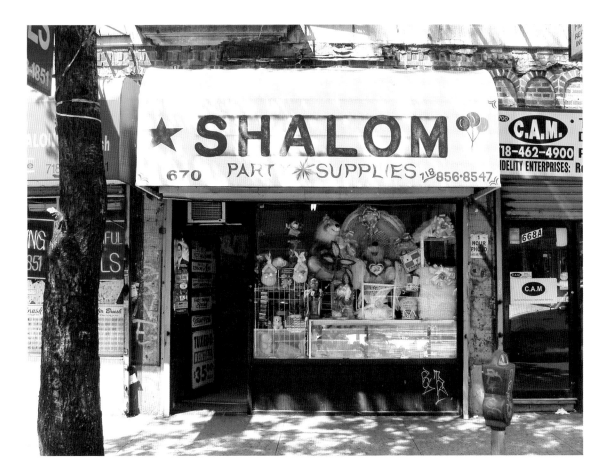

261 Patchen Avenue, Bedford-Stuyvesant

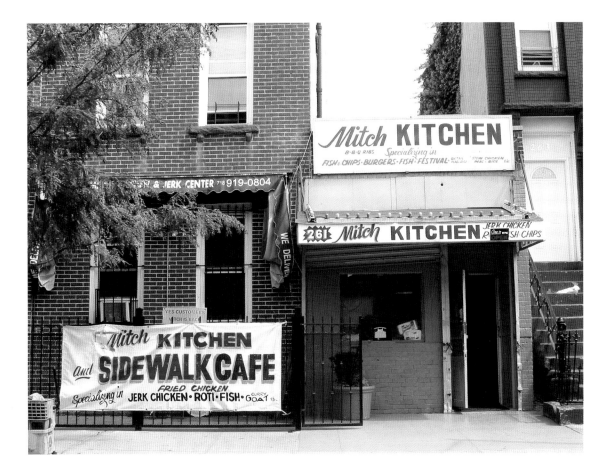

605 Washington Avenue, Prospect Heights

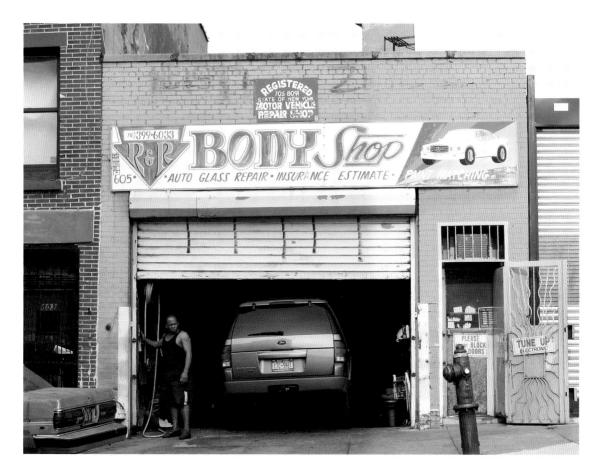

1356 Flatbush Avenue, Flatbush

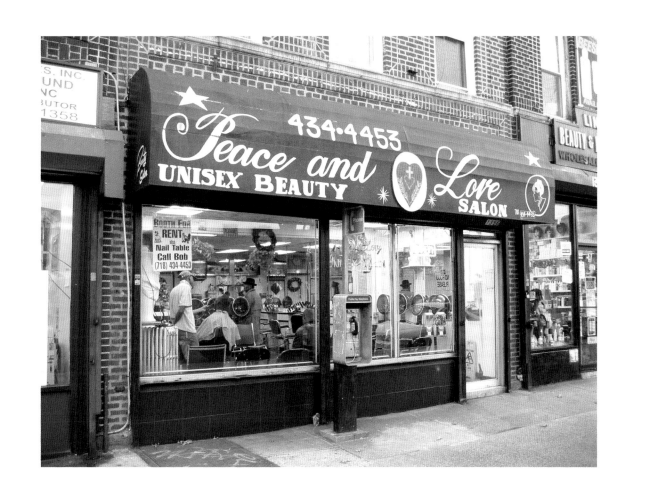

1188 Nostrand Avenue, Flatbush

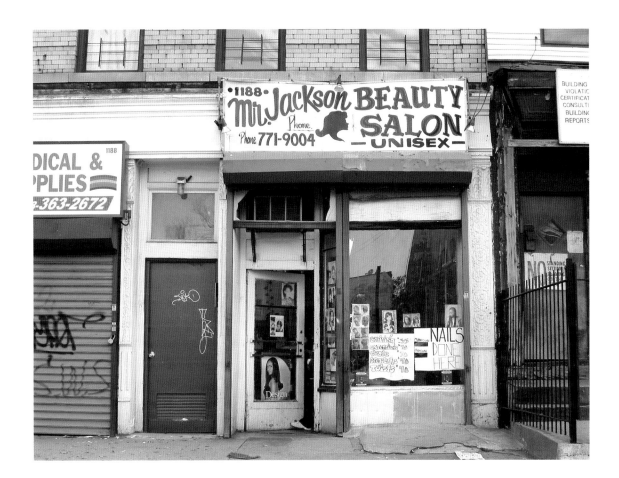

190 Underhill Avenue, Prospect Heights

65 Union Street, Red Hook

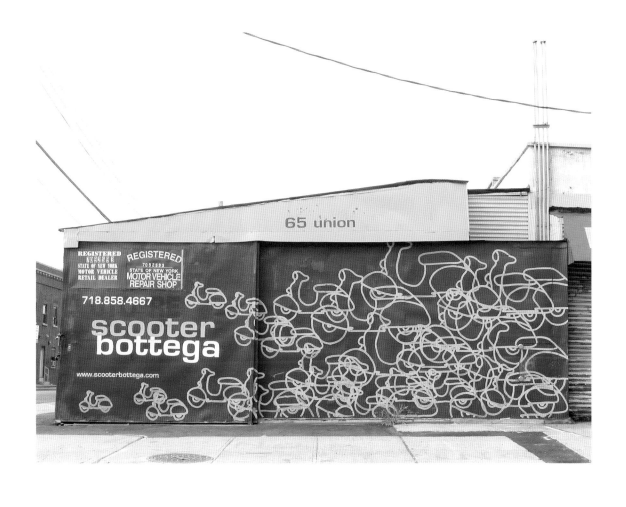

325 Quincy Street, Bedford-Stuyvesant

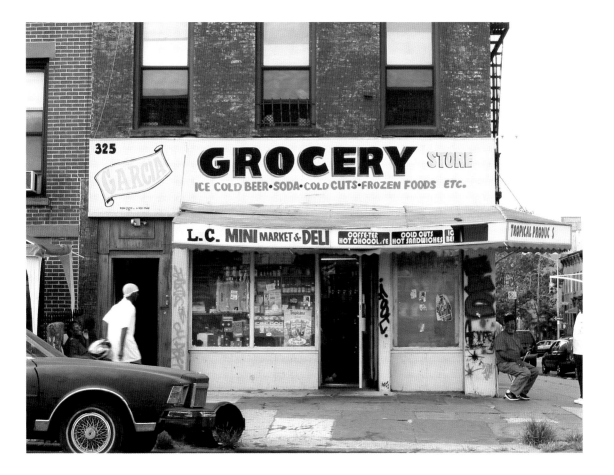

616 Flatbush Avenue, Flatbush

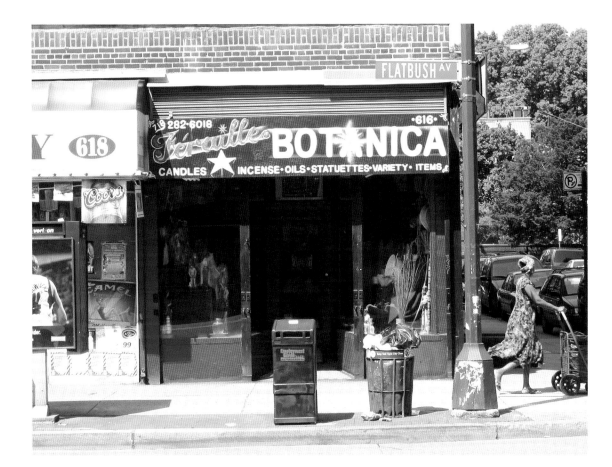

479 Albany Avenue, Crown Heights

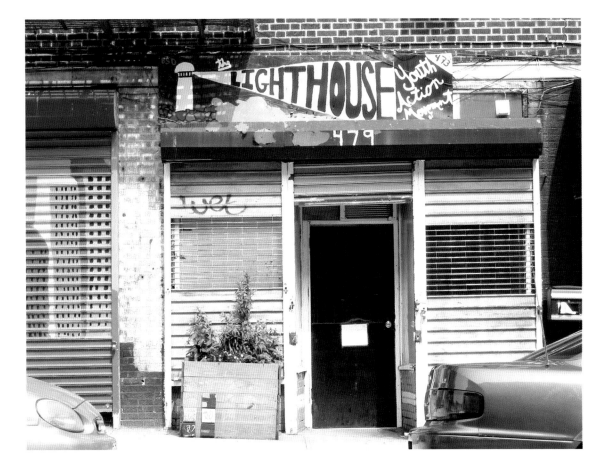

3148 Fulton Street, Cypress Hills

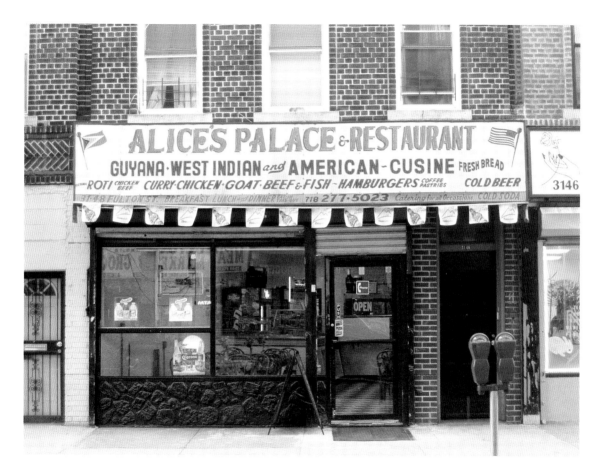

293 Flatbush Avenue, Prospect Heights

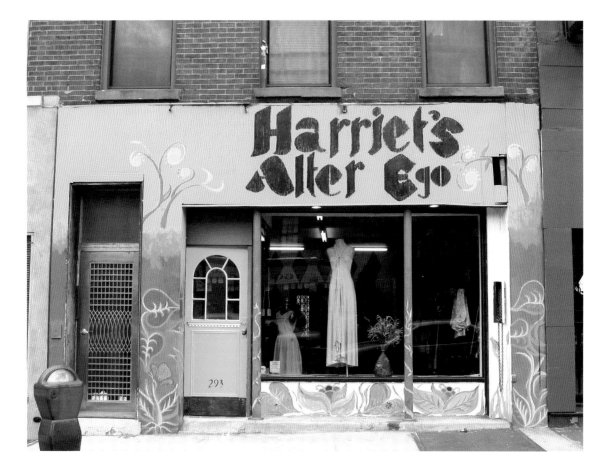

737 Riverdale Avenue, East New York

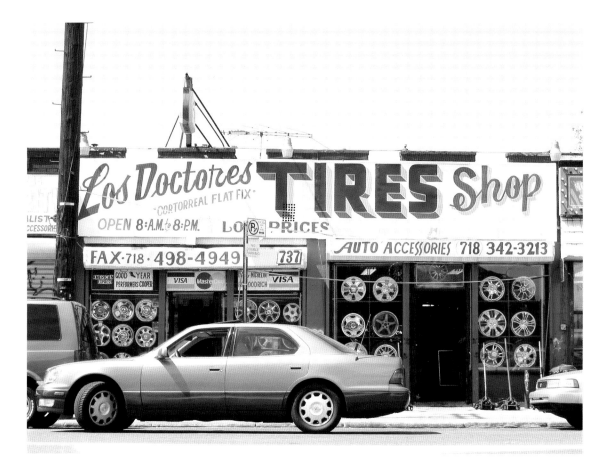

1351 Flatbush Avenue, Flatbush

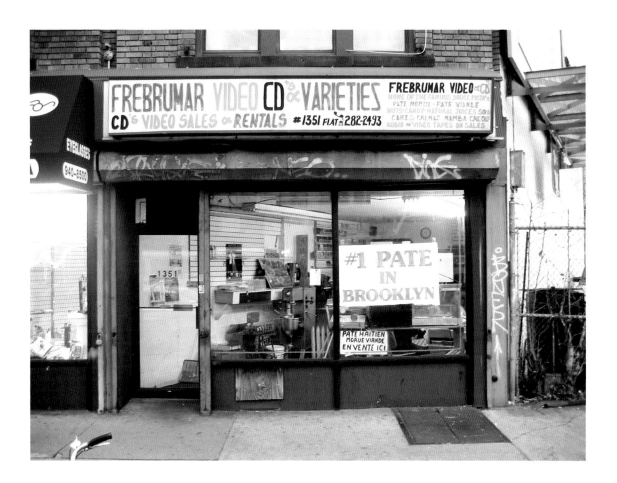

1459 Flatbush Avenue, Flatbush

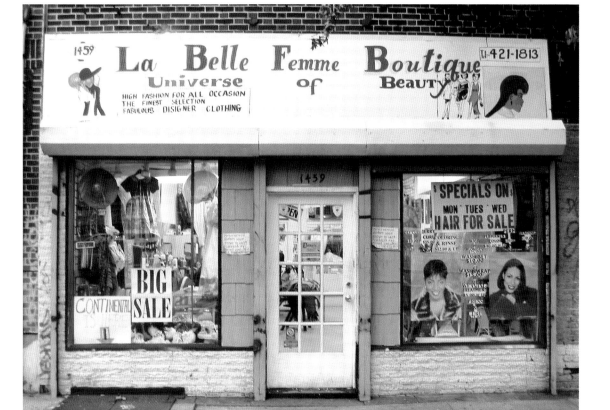

591 Knickerbocker Avenue, Bushwick

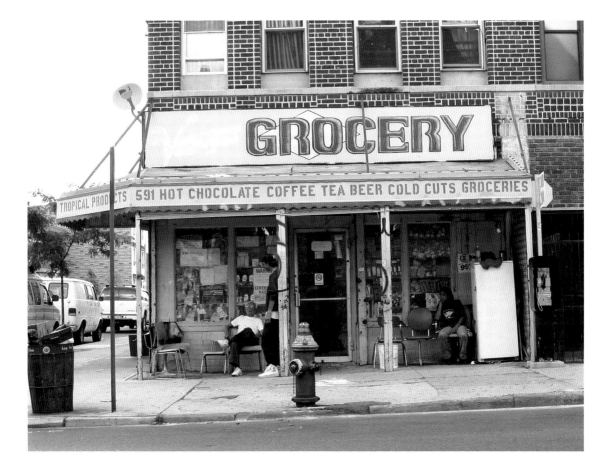

136 Havemeyer Street, Williamsburg

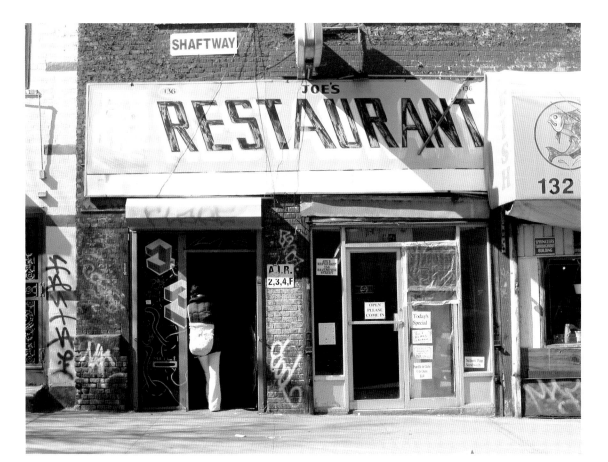

1314 Nostrand Avenue, Flatbush

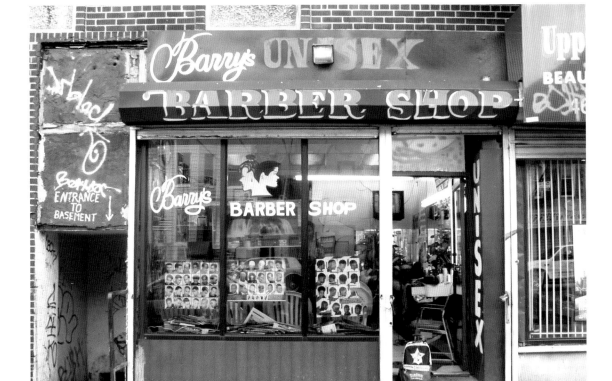

5911 Church Avenue, East Flatbush

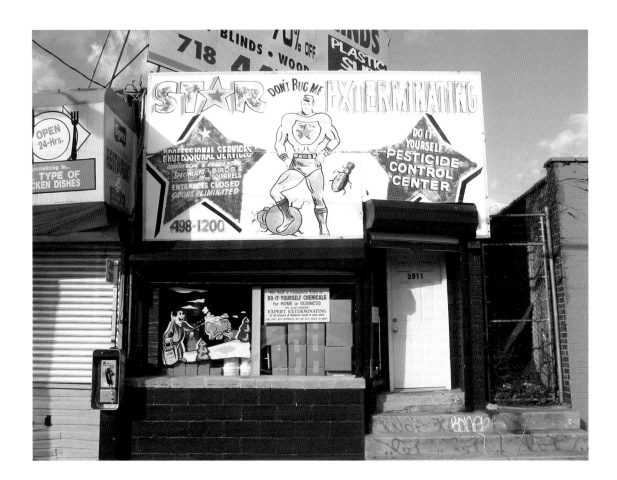

3215 Church Avenue, East Flatbush

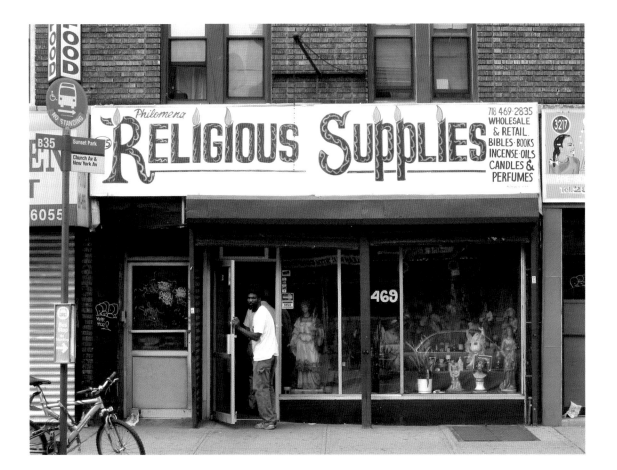

2173 Clarendon Rd., Flatbush

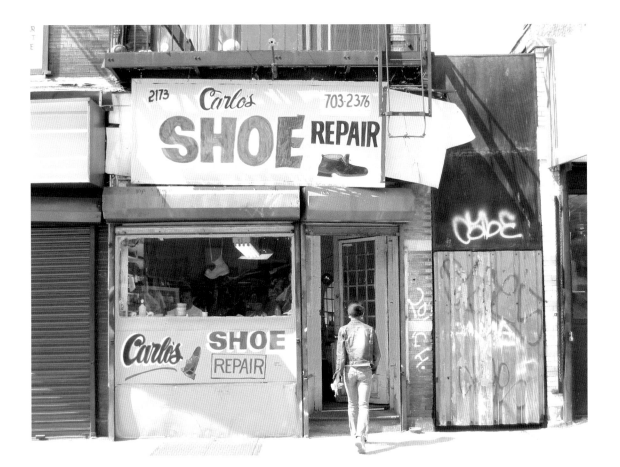

482 Smith Street, Red Hook

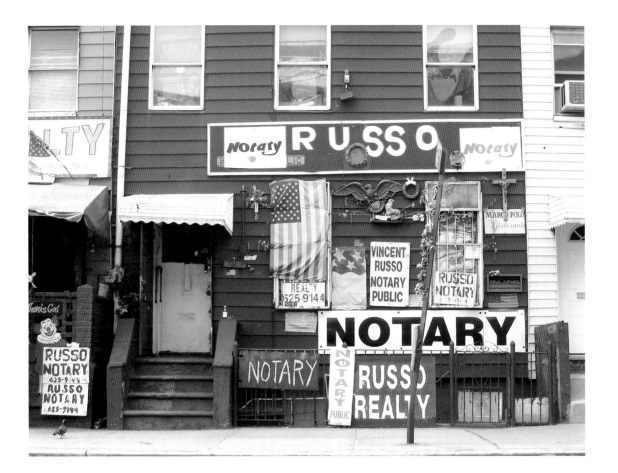

1624 Broadway, Ocean Hill

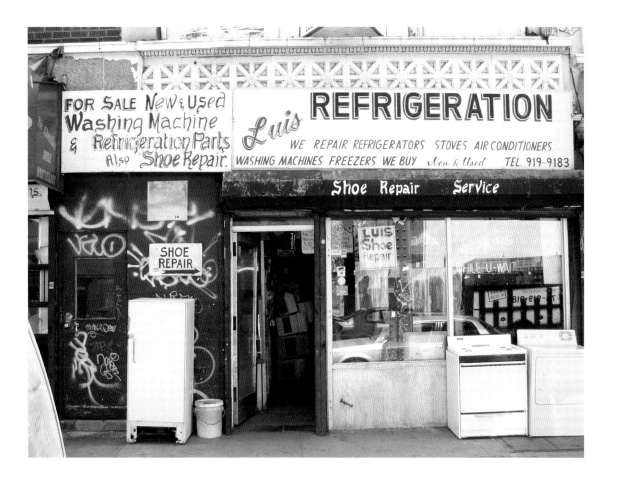

133 Grand Street, Williamsburg

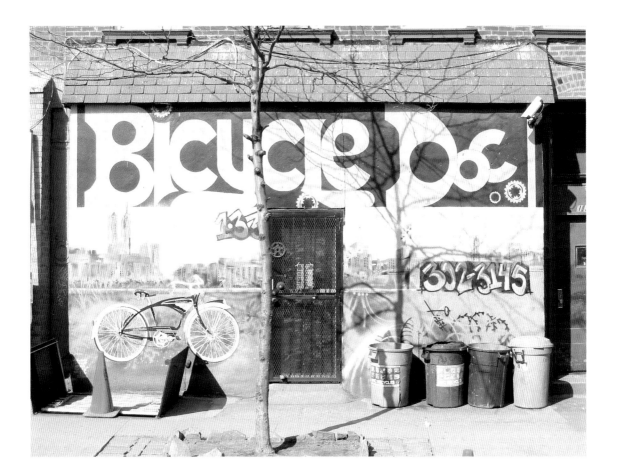

395 Maple Street, Flatbush

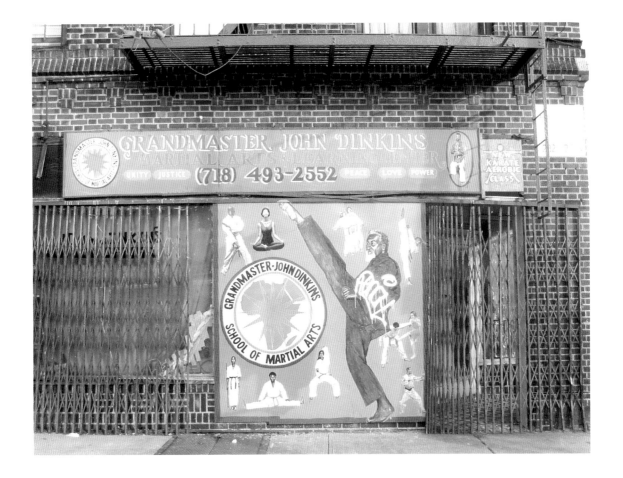

1545 Fulton Street, Bedford-Stuyvesant

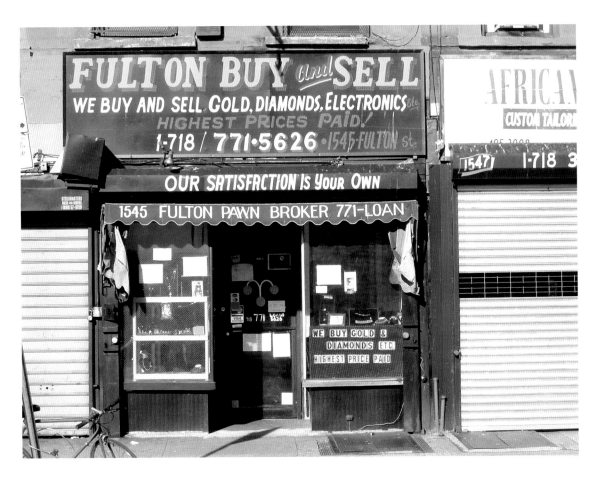

5101 8th Avenue, Sunset Park

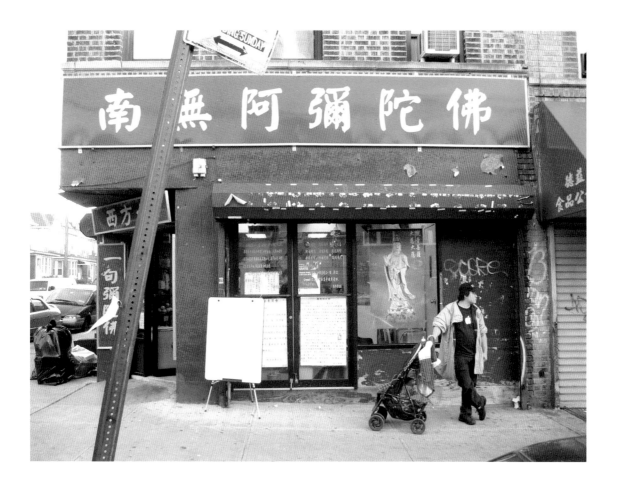

237 5th Avenue, Park Slope

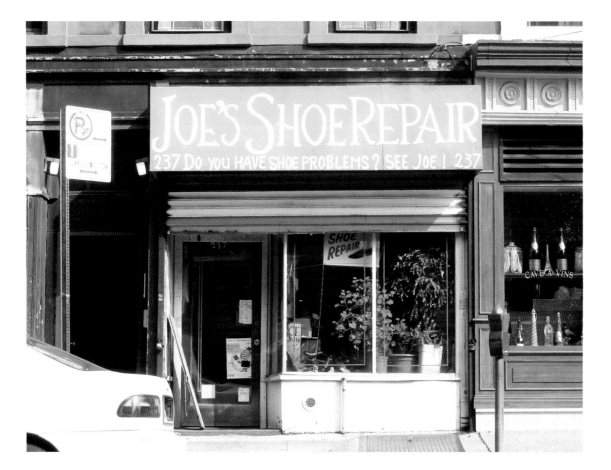

226 Livingston Street, Downtown Brooklyn

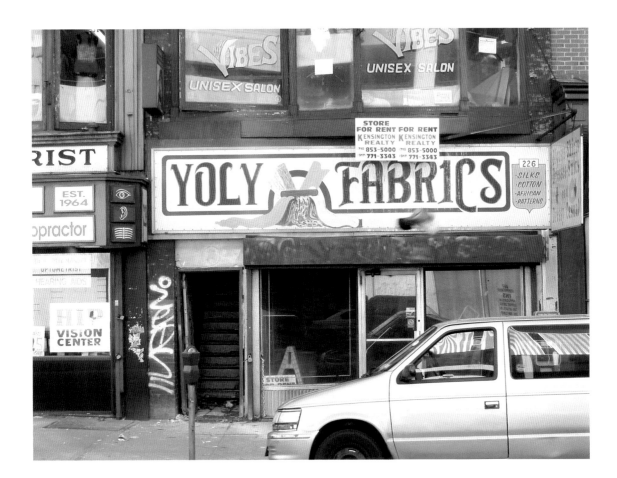

1363 Street Johns Avenue, Crown Heights

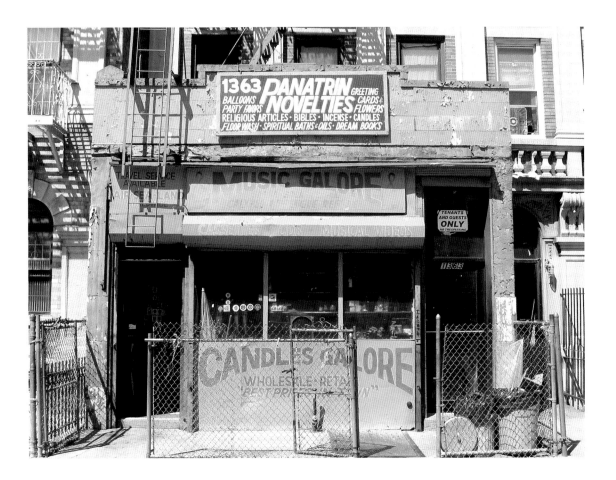

849 Rogers Avenue, Flatbush

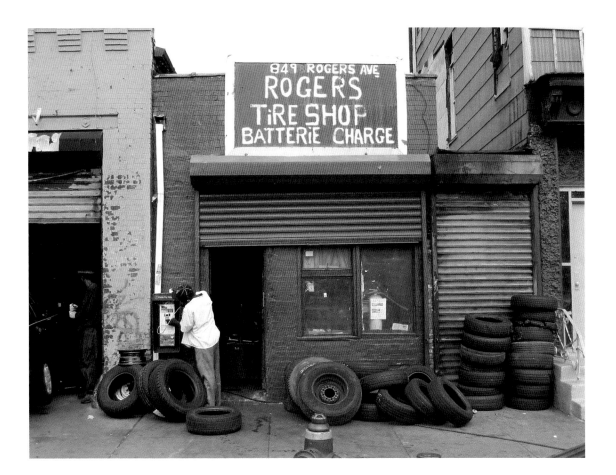

59 Montrose Street, Williamsburg

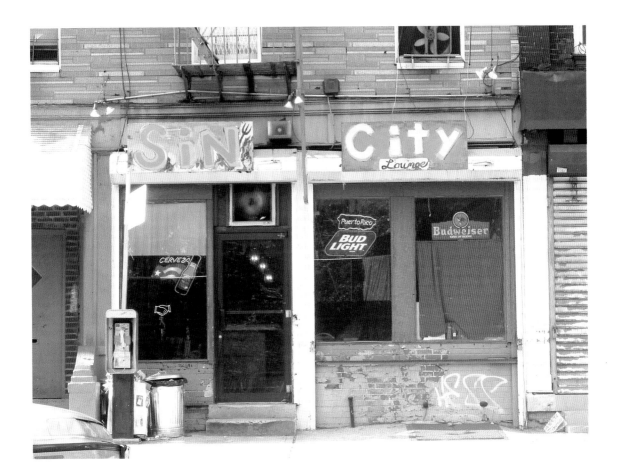

1042 Rogers Avenue, Flatbush

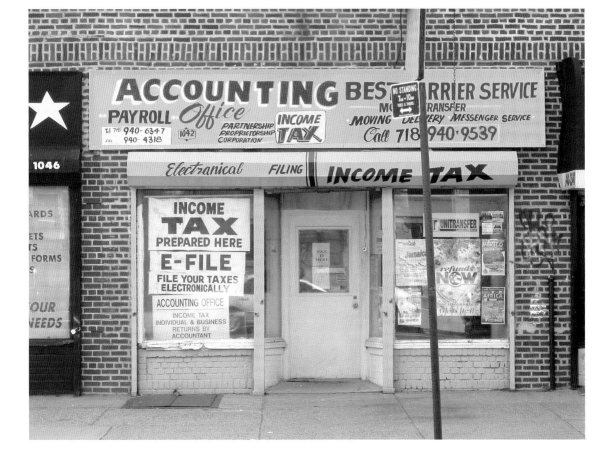

588 Nostrand Avenue, Bedford-Stuyvesant

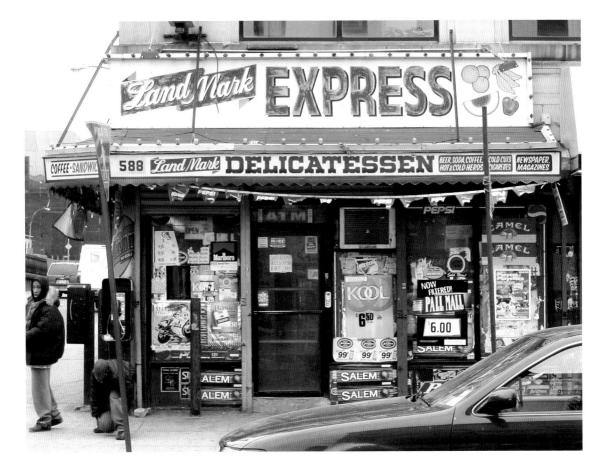

1522 Myrtle Avenue, Bushwick

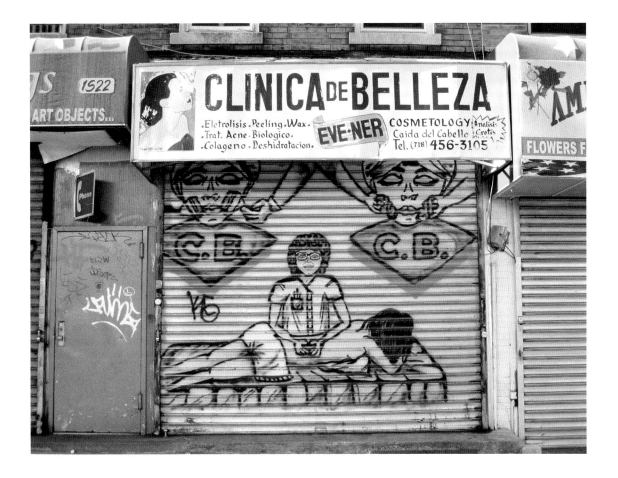

106 Kingston Avenue, Crown Heights

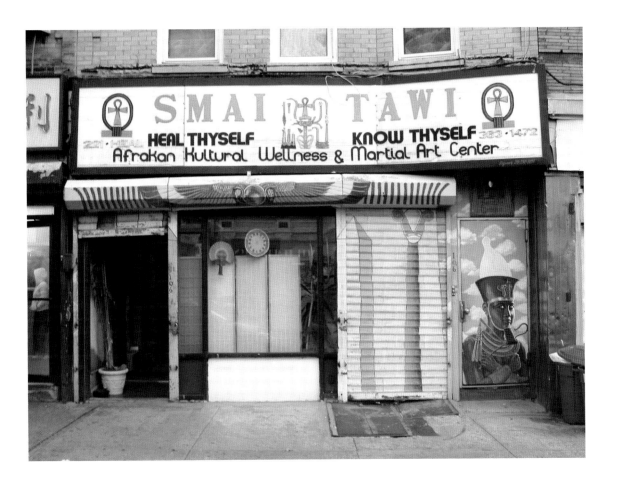

1721 Pitkin Avenue, Brownsville

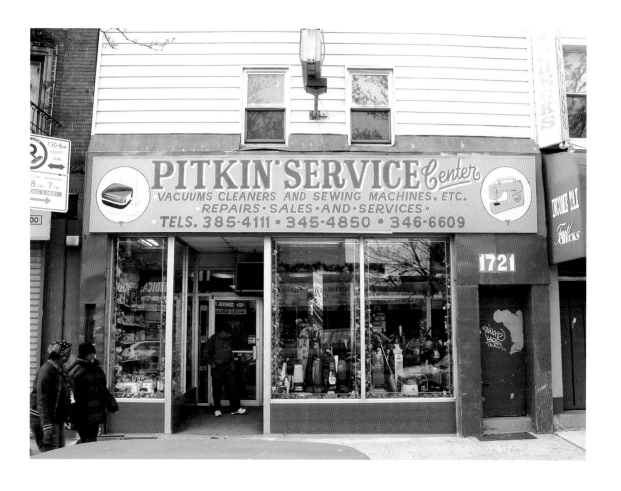

175 Marcy Avenue, Williamsburg

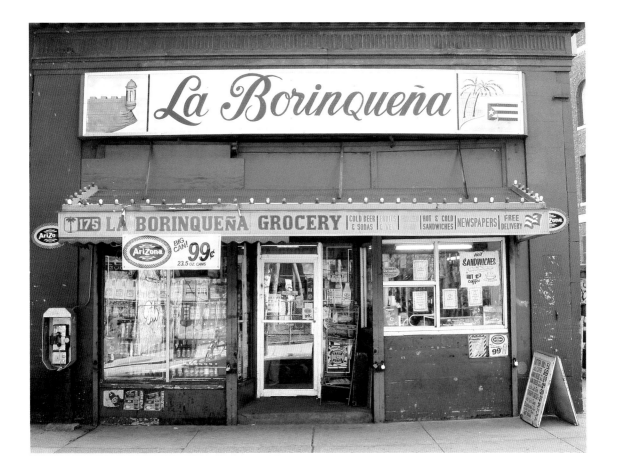

372 Ralph Avenue, Crown Heights

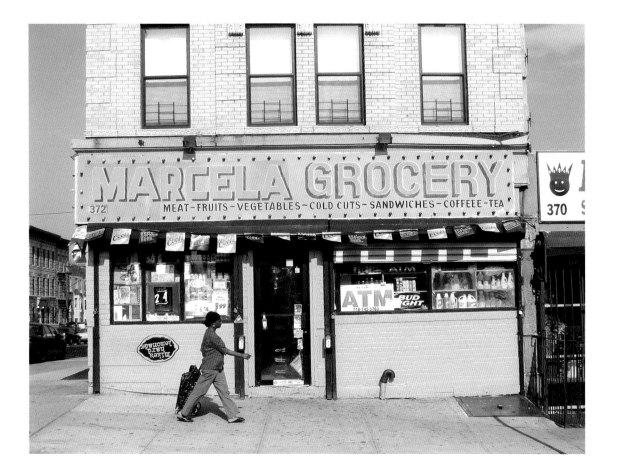

5123 8th Avenue, Sunset Park

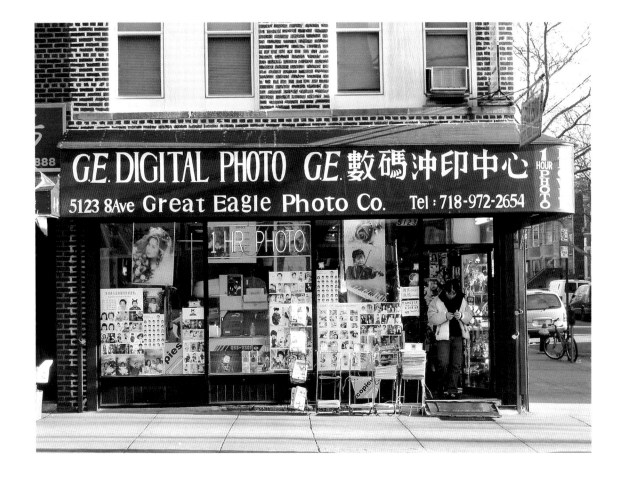

646 Nostrand Avenue, Crown Heights

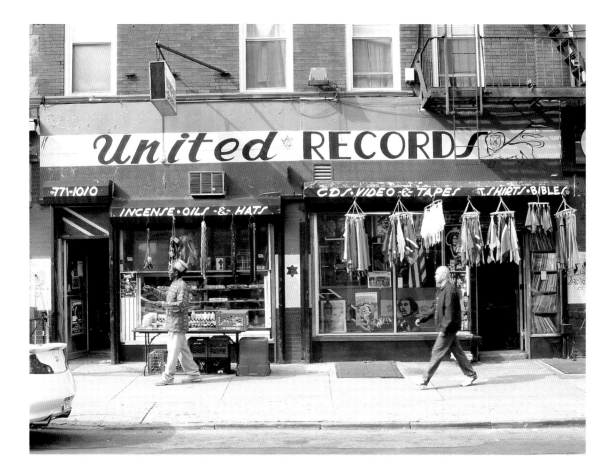

4811 5th Avenue, Sunset Park

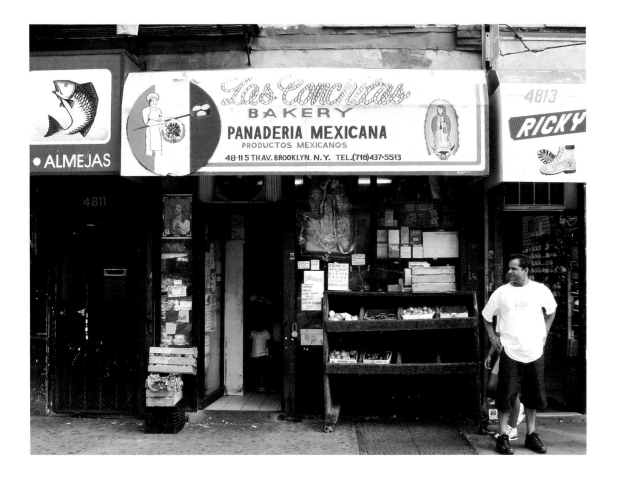

67 Rogers Avenue, Crown Heights

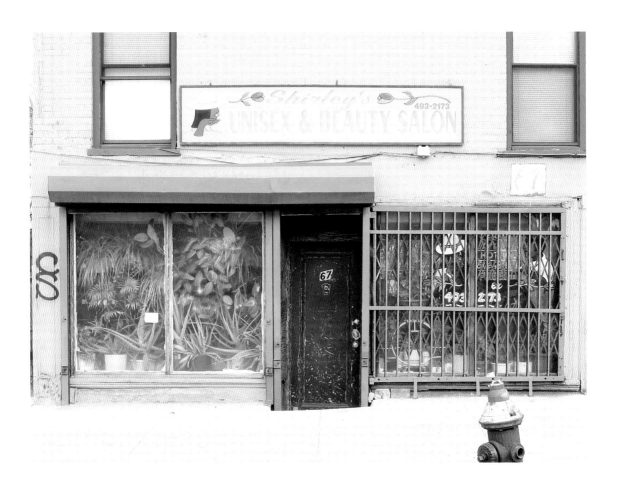

1167 Flatbush Avenue, Flatbush

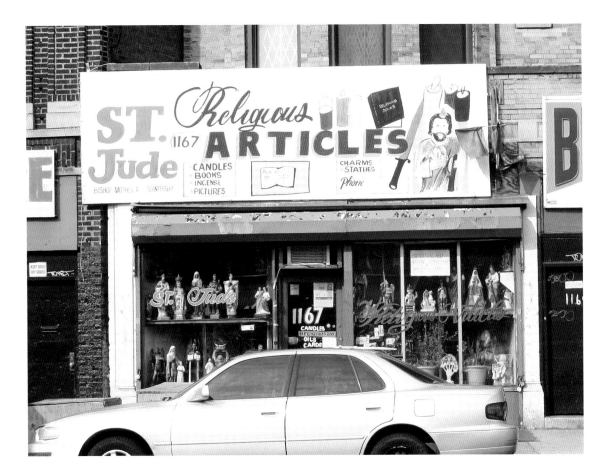

200 Bedford Avenue, Williamsburg

598 Vanderbilt Avenue, Prospect Heights

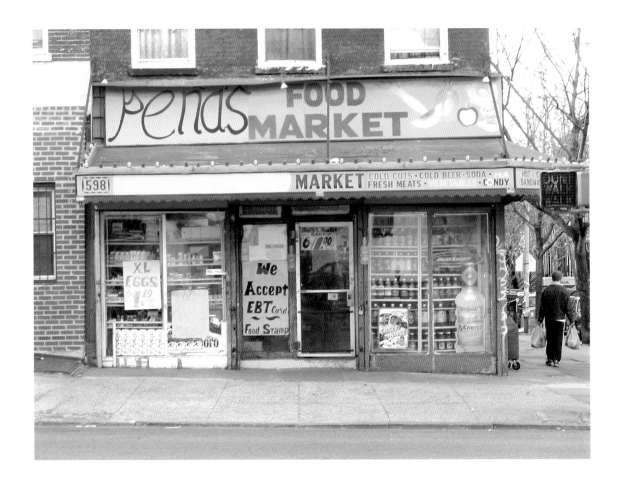

2092 Nostrand Avenue, Flatbush

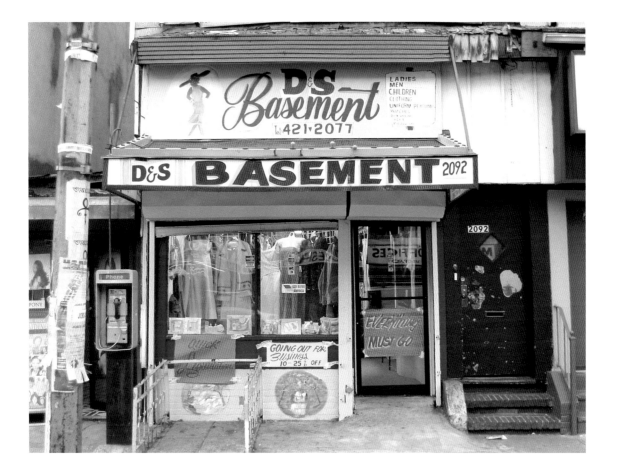

1047 Coney Island Avenue, Flatbush

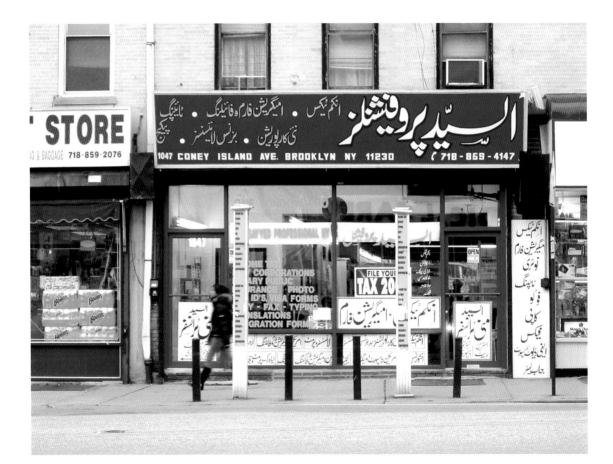

1424 Avenue J, Midwood

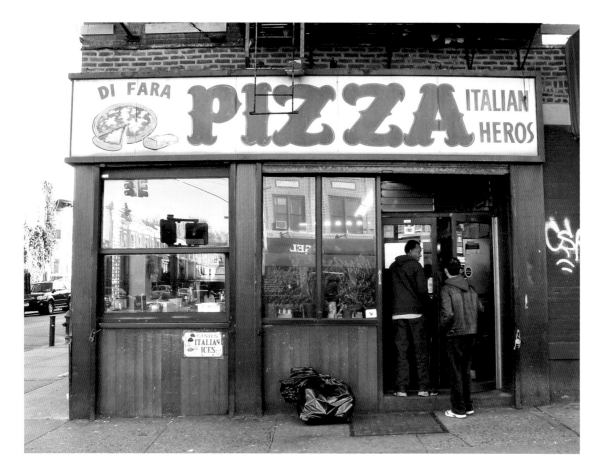

4317 14th Avenue, Boro Park

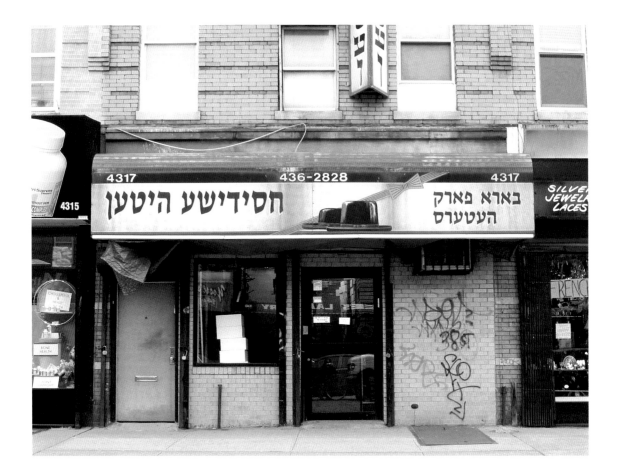

1551 Nostrand Avenue, Flatbush

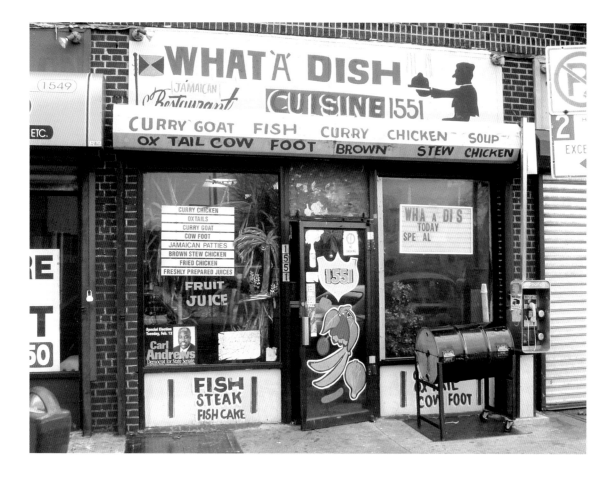

570 Atlantic Avenue, Boerum Hill

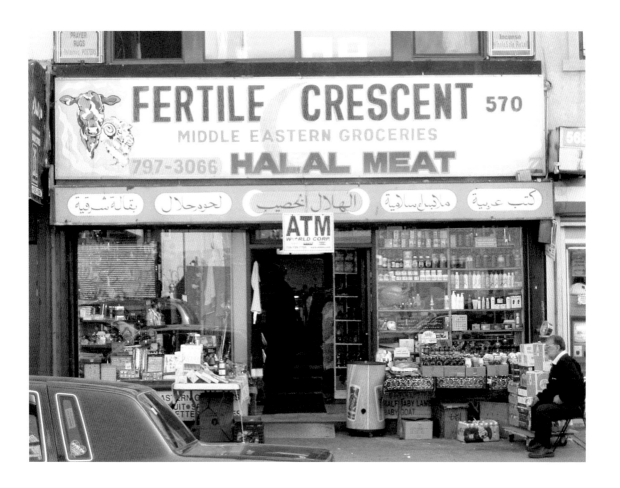

320 Van Brunt Street, Red Hook

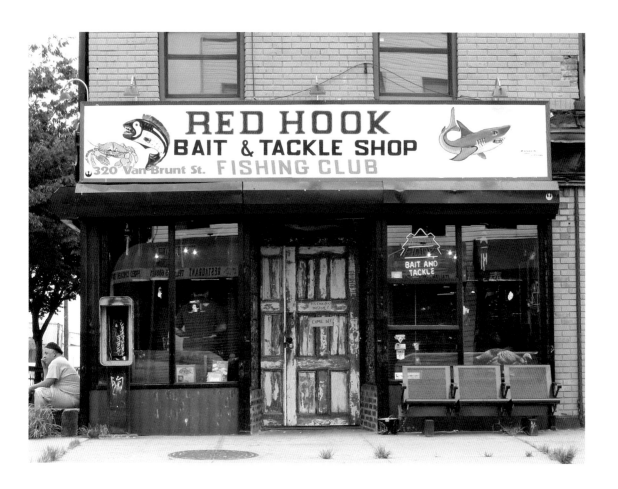

580 Myrtle Avenue, Clinton Hill

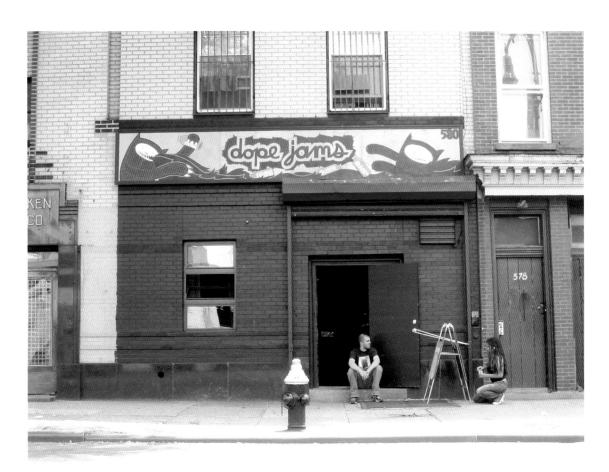